IMAGES
of America

CASPER

This map was drawn in 1905 and shows some of Casper's most important businesses at that time. Spread along Center Street are the Grand Central Hotel, the Natrona Hotel, the Webel & Commercial Company, and the Richards & Cunningham Company. The railroad going through town is the Chicago & North Western. (Courtesy of the Walter Jones Collection, Casper College Western History Center.)

ON THE COVER: Waving their hats to the camera, a group of five cowboys pose in downtown Casper in 1915. The only person identified is Ellsworth Tubbs, who is second from the right. (Courtesy of the Fort Casper Museum.)

IMAGES
of *America*

CASPER

Con Trumbull and Kem Nicolaysen

ARCADIA
PUBLISHING

Copyright © 2013 by Con Trumbull and Kem Nicolaysen
ISBN 978-0-7385-9963-2

Published by Arcadia Publishing
Charleston, South Carolina

Printed in the United States of America

Library of Congress Control Number: 2012935002

For all general information, please contact Arcadia Publishing:
Telephone 843-853-2070
Fax 843-853-0044
E-mail sales@arcadiapublishing.com
For customer service and orders:
Toll-Free 1-888-313-2665

Visit us on the Internet at www.arcadiapublishing.com

*This book is dedicated to the pioneering families of Natrona County
and to the memory of Bryant "Cactus" McCleary
(October 20, 1921–January 16, 2013)*

CONTENTS

ACKNOWLEDGMENTS

The authors would like to thank their families and friends for their support during this project. While this work cannot claim to be a comprehensive record of all of Casper's early history prior to 1960, we feel that the amount of previously unpublished photographs and the scope of the work helps to show Casper developing into the important city it has become.

We would also like to thank Rick Young, Michelle Bahe, and Anne Holman at the Fort Caspar Museum and Vince Crolla and Teri Hedgpeth at the Casper College Western History Center for their help with gathering and scanning the many images in this book and providing much of the information about the images.

Many members of the Natrona County Historical Society provided images and information as well, and we would like to thank Kevin Anderson, Susan Bishop and the Cadoma Foundation, Peggy Brooker, Robin Broumley, Doug Cooper, Vaughn Cronin, Pinky and Jackie Ellis, Ted Leik, Maryalice Tobin, and Dana Van Burgh.

Residents of Casper also contributed information, images from their personal collections, and moral support, and we greatly appreciate the help of Scott Ayres, Ken Ball, Les Bennington, John Buckingham, Doug Crowe, Bill Evans, Kelly Glause, Susan Littlefield Haines, Bob Kidd, Gary and Perri Kay Lathrop, Cactus McCleary, Reid Miller, Jon Nicolaysen, Shelly Nicolaysen, Tim Schlager, Bobbi Stuckenhoff, and Shelly Trumbull. We also greatly appreciate Vicki Burger and Meg Sundell for their encouragement and motivational powers. Finally, we wish to thank everyone at Arcadia Publishing for working with us, and we are most grateful for their patience and support.

Several photographs came from the Fort Caspar Museum and from the Casper College Western History Center; These are credited as (FCM) and (CC WHC), respectively. Photographs from the Carrigen Collection at the Wyoming State Archives, Department of State Parks and Cultural Resources, are credited as (WSA). Photographs from individuals or other sources are credited with the name of the contributor.

All author royalties from the sale of this book benefit the Fort Caspar Museum Association and the Natrona County Historical Society.

INTRODUCTION

Casper was a town built by excited enterprise, by the fellowship of its early settlers, and at times by grander ambition than the industries it depended on could fulfill. It was settled at the end of a rail line in the most remote and underpopulated of territories in a nation recovering from a terrible civil war, along an unreliable river where windy plains and sand dunes meet a gap in the continent's longest mountain range. Before Casper came into existence, the area witnessed the height of the Indian wars and the greatest migrations in the country's history. The area's prehistory is shown in the trails and hunting ways of people who left a mark with cairns and artifacts, while even older history reveals oceans and jungles that would later become the most important factors in Casper's growth from a tent town to a city.

The Native American history of the Casper area reveals overlapping waves of migration. Buffalo traps and artifacts show native peoples hunting in the area around 10,000 years ago. As the Lakota Sioux, Northern Cheyenne, Northern Arapaho, and Eastern Shoshone shifted to horse-based cultures in the 1600s and 1700s, each tribe became familiar with the region as a sort of crossroads. The nearby landmarks of the Laramie Mountains, the North Platte River, the Powder River, and the Bighorn Mountains outlined hunting ranges and winter country for these peoples. Before the waves of North American migration in the mid-1800s, shifting alliances and tribal wars prevented a single group from gaining control of the region, but by the end of the Civil War, the Sioux were the strongest entity in the area.

The trapping boom across the nation in the early 1800s brought trappers through the Casper area, and the first house in Wyoming was the Stuart cabin located outside of contemporary Casper near Bessemer Bend. Robert Stuart returned from Fort Astoria in Oregon in 1812 and built a sturdy, makeshift shelter but gave up plans to winter there because of Arapaho in the area. Stuart and the trappers who came after traveled what would become the Oregon Trail. The fur trade declined in the 1830s, and traffic ebbed until the 1840s through the 1860s, when some 400,000 people sought land in Oregon, gold in California, and religious freedom in Utah. These pioneers' footsteps pressed the ground that Casper would be built upon.

The great trails of America—the Oregon, the California, the Mormon, and the route of the Pony Express—all follow the North Platte River along the Laramie Mountains. The trails left the Platte near present-day Casper, then cut southwest to reach the Sweetwater River and South Pass. New settlers established small encampments in the Casper area and ferries to cross the river. Reshaw's Bridge, built in 1853 by John Baptiste Richard near present-day Evansville, and Guinard's Bridge, built in 1860 by Louis Guinard, were two of the most successful crossings. Raids by Sioux, Arapaho, and Cheyenne were sporadic but ongoing concerns of the travelers, Pony Express riders, and the Richard and Guinard families. Once construction began on the telegraph system, however, Shoshone also began to raid the lines, and an Army garrison arrived in 1862 to build Platte Bridge Station at Guinard's Bridge.

Platte Bridge Station guarded the trails at the border of Indian lands. In 1851, the lands north of the Platte River had been designated as Indian country under the first Treaty of Fort Laramie in

an effort to protect settlers keeping south along the trails. However, when gold was discovered in Montana, the proximity to the older trails made the Bozeman Trail attractive to settlers, and their continued trespassing into tribal lands along the Bozeman proved to be a final aggravation to the tribes. The tribes attacked the garrison on July 25, 1865—first near present-day Mills, then at the Battle of Red Buttes. A young lieutenant, Caspar Collins, was killed while attempting to rescue a wounded soldier, and after the battles, the station was renamed Fort Caspar in his honor.

Throughout the 1860s, the Sioux, Cheyenne, and Arapaho were victorious in several similar campaigns, and the nation focused on building railroads south of the embattled country. When the Union Pacific railroad was constructed through Wyoming Territory in the mid-1860s, it drew traffic away from the old trails, and the fort lost its purpose. In 1867, the fort was decommissioned and torn down, with most buildings moved to Fort Fetterman and the rest abandoned until they were later reused by ranches. In 1868, the Second Treaty of Fort Laramie restricted white settlement to lands south of the North Platte River—in the area where Casper would be founded—but this land soon saw a new type of traffic.

Several cattle grazers had noted the nutritious grasses of the northern plains, and eastern Wyoming was prime summer ground for outfits trailing cattle from Texas. Shortly, the grasses of the territory became the foundation for Wyoming's first industry. Massive cattle companies, generally financed by eastern or British investors, ranged over hundreds of square miles, but the investors owned little of it. Early ranchers deeded streams and creek bottoms to control large watersheds and ran tens of thousands of cattle. Joseph Carey, who was appointed by Pres. Ulysses S. Grant to the position of US attorney for the Wyoming Territory in 1869, began ranching with his brothers in 1876 along the Platte River, where much of Casper stands today. Texas rancher Gilbert Searight started the Goose Egg Ranch in 1877 at Poison Spider Creek. In 1878, Alexander Swan founded the Two Bar Ranch, headquartered near Chugwater, with its northern boundary near Bates Creek. Several ranches were spread throughout the Sweetwater country southwest of Casper as well. At the time, ranchers were limited to trailing their finished cattle to shipping points in Rawlins and Cheyenne.

The cattle range industry was the first to boom in Wyoming, and so it follows that it was the first to bust. Large amounts of capital from the eastern states and Britain poured into the territory, but the industry teetered on inflated numbers of cattle and mismanagement of the range. The winter of 1886–1887 famously brought some of the larger, British-funded companies down by exposing the difference between actual numbers of cattle and ledger numbers. Some of the large companies collapsed quickly, while others dwindled and were bought out by neighbors. Often, cowboys who had previously worked on the big cattle spreads were able to homestead and begin their own operations, in some cases on lands previously run by their former employers.

As the cattle industry waned, sheep ranchers began to flourish. Sheep thrived in the arid climate and were somewhat better adapted to the cold winters of the plains. Thousands of animals had trailed from California to the Rocky Mountains in the 1870s, bringing fine wool to the east. By 1887, Robert Taylor had begun raising sheep along Poison Spider Creek. Taylor had vast experience in California, Montana, and southern Wyoming, but recognized the Casper area as especially well-suited for sheep. Other Scottish friends and kinsmen such as Tom Cooper, David Kidd, and Kenneth McDonald followed Taylor's example and began raising sheep or partnering on shares.

The expansion of the railroad marked the true beginning of Casper as a town. In 1886, the Fremont, Elkhorn & Missouri Valley Railroad (FE&MV) began expanding west from Chadron, Nebraska, into Wyoming. Temporary towns were raised ahead of the railroad in anticipation of the business and settlement the new shipping point would bring. Tent saloons, hardware and equipment stores, liveries, and stables were among the first businesses. The earliest pioneers of Casper surveyed the area and built the tent town near the present-day intersection of A and McKinley Streets. Meanwhile, the FE&MV negotiated first with Joshua Stroud, who homesteaded east of Casper, and then more successfully with Joseph Carey to permanently site the town. Lots were platted, and within a year, the town had moved one mile west to present-day Center Street. Casper was incorporated on April 9, 1889.

The new town was lucky. Oil from natural seeps had been discovered near Casper by Indians and pioneers moving westward along the trails, and it was used as a simple lubricant for wagon wheels and tools. As the nation began to industrialize after the Civil War, petroleum supplanted other types of fuel used for lighting and industrial lubrication. Mark Shannon, a Pennsylvania oilman, came to Wyoming and discovered oil at Salt Creek, north of Casper. He built a basic refinery in Casper to produce simple lubrication oil for gears and valves. Several companies, such as Midwest Oil, Societe Belgo-Americaine des Petroles du Wyoming, and Franco-Wyoming Oil, soon provided funding and drilling expertise to oilmen in the area. By the early 1900s, Casper had three refineries and had become known as a center for oil exploration and production. Demand for gasoline (used in automobiles) eventually overtook that for kerosene (used in lights), which brought yet more investment to the area.

Casper, which served as the western terminus for the FE&MV until 1905, quickly became a regional hub for business and industry. Wool, cattle, and oil were brought to Casper, where they could then reach larger markets by train. Local banks and businesses prospered by supplying freighters, ranchers, oil companies, and the town's growing population. Wool production increased dramatically throughout Natrona County, and it became the first important industry for the town. During the first decade of the 20th century, Casper companies shipped tremendous amounts of wool and sheep, bringing prosperity to many recent settlers and attracting more. The city steadily grew as demand increased for its commodities through World War I.

The 1910s brought expanded oil production through better drilling practices, and by the early 1920s, Casper proudly called itself the "Oil Capital of the Rockies." The vast deposits of high-quality oil near Casper made it a welcoming setting for refineries and transport. As the automobile age began, Casper's busy downtown area offered a clear sign of prosperity. But as the nation suffered during the Great Depression, Casper followed. After the exuberance of the 1920s, the sharp drop in population during the rapid decline of the oil industry was repeated throughout the century.

Casper recovered in the 1940s, as its commodities were in heavy demand in wartime. In a partial echo of the events of the 1860s, the military, which built a large Army air base northwest of the old Fort Caspar grounds, brought some stability to the area. The 1950s seemed set to be another time of expansion for the town as better oil production techniques, stable demand for beef, and a new uranium exploration industry flourished.

In some ways, the early history of Casper is like that of many other western towns established by rail companies and ranchers. Yet Casper was also formed by the dedication of its immigrant settlers and their belief that this place was one of opportunity and possibility. Many simply came to find work and stayed in the area. Others sought to build empires, hoping their town would challenge Denver—or at least Casper's great rival, Cheyenne. The boosterism throughout the United States in the early 1900s infected Casper at times, but its citizens continued to build strong social organizations. Like many other western towns, Casper suffered economic busts that now seem inevitable. And while the boom-and-bust cycle always seems to recur, Casper has been able to struggle through, surpassing its previous mark each time. The founding fathers and mothers would be proud to see their city today.

—Kem Nicolaysen

One

PIONEERS ON THE PLATTE

This 1888 image depicts Casper as a tent town near present-day McKinley and A Streets. Tent towns like this preceded railroad construction and took advantage of the influx of workers and settlers until a more permanent site was platted. W.W. Sproul's freight team is in the center of the image. Sproul hauled supplies for the railroad, and, later, the oil fields. A caption on the back of the photograph notes the bones in the lower right corner. (FCM.)

Ferdinand Hayden was selected by the Department of the Interior to lead the first federally funded geologic survey of what would later become Yellowstone National Park. In this 1870 photograph, the Hayden party is near Red Buttes, along the North Platte River just west of present-day Casper. The expedition consisted of 38 members, including famous photographer William Henry Jackson. (Casper Centennial Corporation Collection, CC WHC.)

In 1812, Robert Stuart constructed the first building erected by non-natives in Wyoming. He and his fellow trappers were returning from Oregon through Wyoming and selected an area near Bessemer Bend as their winter campsite. They constructed a cabin and settled in for the winter but moved farther south when the threat of trouble from Arapaho Indians convinced them to leave the region. This photograph shows what may be the remains of that first cabin in a location about eight miles west of present-day Casper. (Blackmore Collection, CC WHC.)

In 1871, after serving for two years as the first US attorney for the District of Wyoming, Joseph M. Carey began ranching with his brother R. Davis along the North Platte River in the mid-1870s. He negotiated with the Fremont, Elkhorn & Missouri Valley Railroad (FE&MV) to site Casper a few miles east of his ranch buildings. Carey was later a US senator from and then the governor of Wyoming. His ranch and cattle brand was called "CY" after the first and last letters of his name. The ranch and its brand are memorialized by CY Avenue in Casper. (David Historical Collection, CC WHC.)

Below, CY cowboys sit at the roundup wagon, with foreman Bob Divine at the far left. During the time of open-range grazing, CY cattle ranged as far as the Red Wall in Johnson County, 100 miles north of the ranch; in 1896, Divine confronted alleged rustlers there and was involved in a shoot-out that killed a man named Bob Smith. (David Historical Collection, CC WHC.)

This photograph, which was taken in the late 1870s or early 1880s, shows some of the early cowboys of Casper, some of whom worked at the CY and Goose Egg ranches. They are, from left to right, (first row) Charlie Dasch and William "Missou" Hines; (second row) Tom Lamb, who later ranched east of Casper along Hat Six Road, and John Morton. Hines worked at the VR, CY, Swan Land and Cattle, and Goose Egg ranches before beginning his own ranch east of Casper near Muddy Creek. Hines, a notorious figure who may have inspired the famous baby swap in Owen Wister's book, *The Virginian*, was nicknamed for the twang he picked up in his home state. Hines later worked in the Salt Creek oil field as an enforcer protecting the interests of William Fitzhugh, an early oilman. (Nicolaysen family.)

Jake Hudson (left) and Hugh "Colorado" Patton display a trophy from their latest hunt. Patton, who was also a cowboy on early ranches near Casper, served as constable, sheriff, and state legislator of Natrona County and had several business interests in Casper. (Nicolaysen family.)

"Old Town" Casper is seen here in 1888, before the town was platted at Center Street. The Demorest Home Restaurant was one of Casper's first businesses, along with Metcalf & Williams, a clothing supply store. Pioneer Drug Store moved to Center Street and successfully operated for many years. It was started by Charles Bostleman but was eventually sold to Wilson S. Kimball, another early pioneer, who later changed the name to "Kimball's Drug Store." (Sheffner-Butler-Schulz Collection, CC WHC.)

John Merritt was credited as the first settler of Casper after setting up camp along the North Platte River in 1888. After several other groups joined his camp, Merritt signed the application to found the new town. The next year, the tent town of Casper was established in anticipation of the arrival of the railroad. After living in Casper for 10 years, Merritt moved to Joplin, Missouri. (Frances Seely Webb Collection, CC WHC.)

George Mitchell was one of early Casper's most prominent figures. After he helped to get the town incorporated, residents elected him the first mayor of Casper in 1889. He also served as one of the first county commissioners. Mitchell ran the Wyoming Lumber Company, which provided lumber for many of Casper's first buildings. (City of Casper Collection, CC WHC.)

Wilson S. Kimball edited the *Wyoming Derrick* and later bought Pioneer Drugs from Charles Bostleman. Kimball successfully ran the drugstore for many years. (Frances Seely Webb Collection, CC WHC.)

Peter Demorest and his wife, Hannah, operated Casper's first restaurant for a railroad contract, supplying food for rail workers from Omaha to Casper. The Demorest Home Restaurant, located on Center Street, soon became a popular gathering place for city residents. Demorest became active in early city politics, serving as one of the members of the first city council and as a member of the school board. (FCM.)

Peter C. Nicolaysen was a Danish immigrant whom George Mitchell identified as the third man to settle in Casper. After running a railroad saloon for a short time, he sold it to "Colorado" Patton, bought Mitchell's lumber company, and began ranching east and north of Casper. He was elected to one term as mayor of Casper and served on the Casper National Bank board for many years. He is pictured here in his early 30s. (Frances Seely Webb Collection, CC WHC.)

Bryant B. Brooks was born in Bernardston, Massachusetts, in 1861, completed college in Chicago in 1878, and came to Wyoming in 1880 to experience the adventure that the West had to offer. Brooks arrived in the Casper area in 1881 and acquired a cabin in 1882 that provided the start of his ranch, the V Bar V. After he worked to help form Natrona County in 1890, he served as governor of Wyoming from 1905 to 1911 before returning to Casper and entering into several business ventures. (McCleary family.)

William T. Evans emigrated from Wales to Nebraska with his family for the health of his wife, Elizabeth. He then came to Casper and built several of the earliest buildings in town, many of which still stand. He was a skilled mason who also began ranching east of Casper. Later, he founded nearby Evansville. (Western History Collection, CC WHC.)

Patrick Sullivan was an Irish immigrant who began as a shepherd and rose to become an influential businessman. Sullivan's success, along with that of cousins "Denver" Tim and "Rawling" John Mahoney, two other early Irish immigrant sheep ranchers, encouraged many other Irish settlers to come to Casper during the sheep industry's booming years. Sullivan served several terms as a Wyoming state senator and one term as a US senator. (Anderson Collection, CC WHC.)

A group of schoolteachers is pictured on horseback in downtown Casper. Several schoolteachers married local ranchers and used their education and love of history and arts to develop clubs and organizations in Casper. After marriage, women were not permitted to continue teaching because common knowledge assumed they had greater responsibilities within their households. Nevertheless, the teachers' service instilled culture in the prairie town. (Doug Cooper.)

Long before the railroad reached Casper, the Stroud family operated one of the area's earliest ranches. Life in the area was harsh, and Cheyenne was the closest town in which to get supplies, but the Strouds persevered. Joshua Stroud constructed this comfortable cabin in 1881; it still stands today. (Lathrop family.)

Two

RAILS CONNECTING CASPER TO THE WORLD

On May 8, 1950, Pres. Harry S. Truman arrived in Casper to visit the Kortes Dam project located west of town. In this image, the president is speaking from the back of the presidential railcar to the crowd that had gathered at the Chicago, Burlington & Quincy (CB&Q) depot. In 1946, construction began on the Kortes Dam (named for the nearby Kortes Ranch), which would supplement irrigation from the Platte River. (Chuck Morrison Collection, CC WHC.)

CHICAGO & NORTHWESTERN DEPOT AND THE MONUMENT.

Casper's first railroad, the Fremont, Elkhorn & Missouri Valley (FE&MV) Railroad, arrived on June 15, 1888. This railroad was later consolidated under the parent company Chicago & North Western (C&NW) in 1903. In 1910, the C&NW built a permanent depot, which is shown on this postcard from the 1920s. The building remained until 1988, when it was torn down. The Pioneer Monument obelisk at right was moved to Center Street in front of the courthouse. (McCleary family.)

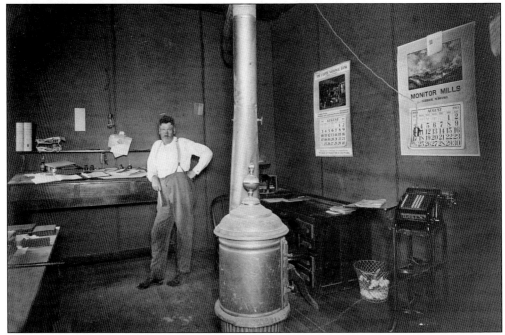

The arrival of the railroad marked a fast, efficient, and cheap way for travel and for local businesses to ship and receive products. William F. Dunn, the first C&NW railroad agent, was tasked with selling tickets and billing freight. He is pictured in his office at the C&NW station in 1913. (FCM.)

In 1906, the C&NW extended the line from Casper to Shoshoni. The first stop west of Casper was Cadoma, where Marvin Bishop, a sheep rancher since 1898, owned and operated large shearing pens for the use of many nearby sheep ranches. The Cadoma townsite was approximately 10 miles north of the current site of the Natrona County International Airport. A nearby stop on the Chicago, Burlington & Quincy (CB&Q) extension was named after Bishop, and he also had shearing pens there. Wool and sheep were both shipped directly from the stations. Bishop was a founding member of the Natrona County Woolgrower's Association, which was established to protect stock driveways and the interests of sheep ranchers. (Cadoma Foundation.)

BURLINGTON DEPOT, CASPER WYO. © WAS. # 27

The second railroad to pass through town, the Chicago, Burlington & Quincy (CB&Q), reached Casper in 1913. After using a temporary depot for two years, construction began in May 1915 on the permanent depot; it was completed on February 3, 1916. This view shows the depot soon after the completion of construction. The building is now used by the BNSF Railway Company. (FCM.)

This photograph captures a locomotive crane working in the Burlington & Missouri (B&M) rail yard. The B&M was a subsidiary of the CB&Q and was soon absorbed into its parent company. (Chuck Morrison Collection, CC WHC.)

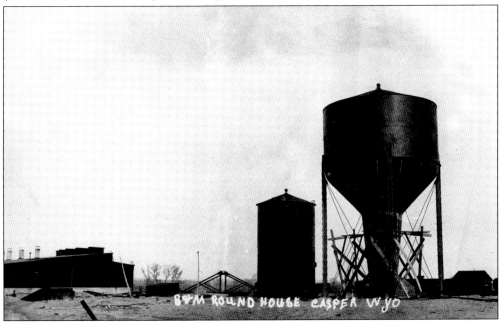

The B&M built a roundhouse and a water tower in the Casper yards to service the steam locomotives. The facilities were used by the CB&Q until diesel locomotives came into widespread use, and the steam locomotive facilities were torn down. (Chuck Morrison Collection, CC WHC.)

On September 27, 1923, a storm caused Cole Creek to overflow its banks east of Casper, washing out the railroad bridge on the Chicago, Burlington & Quincy (CB&Q) line. A passenger train derailed at the site, and the locomotive and five of the train's cars crashed into the stream. The wreck took 30 lives and was the worst railroad accident in Wyoming history. These two images show the aftermath of the wreck, which made national headlines during the cleanup and recovery efforts. (Above, Nicolaysen family; below, FCM.)

Three

A Growing City

This c. 1915 view of Center Street from present-day 13th Street shows Casper's growing downtown area and several of the large houses of the South Wolcott Historic District. Sheep ranchers and city businessmen built many of these houses near the height of the sheep industry in Casper. The Sullivan, Cunningham, and Kidd houses are all visible in the foreground, as well as Central School (to the left of the street with a white cupola) and the second county courthouse (in the center at the end of the street) at the north end of Casper. (Robert Kidd.)

These two scenes from Casper's downtown show the changes that occurred as it transitioned from a frontier rail town to a bustling city. The 1890 image above shows Center and Midwest Streets looking north. Several buildings from Old Town had moved to the city center—Graham House (left) is a prominent hotel, and saloons, billiard halls, and hardware stores are also on the left. In the image below, electricity had come to Casper, and so had the new courthouse at the end of Center Street. The dirt roads date this photograph to soon after 1908. The location is approximately the same, and hotels, bars, and pool halls still line the west side of the street, although more newly constructed. The Rhinoceros Restaurant, the Townsend block, and the Midwest Hotel are also visible. The small house with a porch was the office of Drs. Hoff and Kemp. (Both, FCM.)

The intersection of Second and Center Streets (pictured above in the mid-1920s) featured Casper's first—and, at the time, only—traffic light. The Townsend block, with Stockman's National Bank, is at left, while the Rialto Theater, advertising a Greta Garbo film, is at right. The automobiles offer a marked contrast to earlier photographs, as do the three grand hotels at First and Center Streets—the Townsend, the Henning, and the Gladstone. The Con-Roy building is the tallest one at right. The 1930s photograph below was taken slightly south of Midwest Street on Center Street. The Natrona Hotel building, pictured before its destruction, was occupied by A.F. Lockhart, a real estate and livestock agent. Kistler Tent and Awning is just behind it. Signs for Tripeny Drugs and the Golden Rule Store are also visible. (Above, Art Randall Collection, CC WHC; below, Western History Collection, CC WHC.)

The c. 1901 photograph above looks south on Center Street between Second and First Streets. The Townsend block has not yet been built, but Charles H. Townsend has opened his store where the block will later be built. The Grand Central Hotel dominates the west (right) side, and the Richards and Cunningham store is directly across from it. Farther south, the white Natrona Hotel is a busy place. A railcar is at the far end of the street. In the 1912 image below, taken at Center and Second Streets, the Richards and Cunningham store has been modernized. The large house in the distance, on Tenth Street, was built for Patrick Sullivan in 1909 and still stands. Joseph Carey, who wanted to encourage other beautiful residences in the area, gave Sullivan the land for the house; this was the beginning of what is now the South Wolcott Historical District. (Above, Nicolaysen family; below, FCM.)

The image above looks south at Center and First Streets in the 1920s. The grand Hotel Henning (right) and the Con-Roy building (left) are the tall structures, and Casper's oil boom was underway. The Iris Theater (at right) and the America Theater (at left) have the most impressive fronts. Harry Yessness's clothing store was in the Con-Roy building, and the street-level businesses in the Hotel Henning building included Richter Music and Burnett-Hynes Optical Company. In the distance, snow is on Casper Mountain. The photograph below was taken in the early 1930s in front of the courthouse and shows Casper's large hotels (Townsend and Gladstone), the smaller Wyatt and Court Hotels, and the Arkeon Dance Hall, a popular ballroom and band theater. (Above, FCM; below, Art Randall Collection, CC WHC.)

The photograph above, which looks east between Center and Wolcott Streets on Second Street in the early 1890s, shows a curious scene with a wagon of electioneering Casperites. The portraits on the wagon are likely of politicians. The building under construction is the Odd Fellows building, which was completed in 1896 by William T. Evans and is the oldest surviving building in downtown Casper. Evans also built St. Mark's Episcopal Church (in the background) in 1891. The church, Casper's first, was moved twice and now stands on the county fairgrounds. Below, Casper appears dramatically different looking east at Second and Center Streets in 1922. In the right foreground is the Casper National Bank, which took the place of the Richards and Cunningham store. In the distance at left is the Midwest building, which housed the Wyoming National Bank. The Odd Fellows building, located between the Midwest building and The Bootery, is completed. Lukis Candy and the Kassis clothing store are at right before Wolcott Street. (Both, FCM.)

Above, looking west at Wolcott and Second Street in the 1920s, the Odd Fellows building takes up much of the right side, while the Ormsby-Scherck building is two doors down. Between the two is Woolworth's, which was housed on the ground floor of the Odd Fellows building until the 1980s. The Townsend block is in the distance at Center and Second Street. The photograph below shows Wolcott and Second Streets in the 1940s. This side of the street held many clothing stores, such as Kline's, Kassis, and the Golden Rule Store. Casper National Bank is at the end of the block. Almost all of these buildings still stand today. (Above, FCM; below, Western History Center, CC WHC.)

Casper Fire Department's Station Two was constructed on David Street in 1920. Here, firemen pose in front of it with their firefighting equipment. After Station One was destroyed by fire, this became Station One—the number on the building today. At left is the municipal garage, which has since been demolished, and to the right of the fire station is the first Natrona County Courthouse building, which was erected in 1895. The courthouse soon proved too small for the

county's growing population, and the town government decided that a newer, more modern courthouse was necessary. The new courthouse was completed in 1908, and the one seen here was sold. When this photograph was taken in the 1910s, the old courthouse had been converted to the Asbestos Headquarters. (Western History Collection, CC WHC.)

This early view of downtown Casper shows the region along the North Platte River known as the Sandbar. Casper's early builders bypassed this area for downtown because the instability of the ground was not suitable for large buildings. The area became a haven for Casper's poorer population and was later home to the notorious red-light district. Here, some sheep wagons are camped among the shacks. The street in the lower left corner of the photograph is Center Street, and the large building is the Midwest Hotel, which was financed by the Midwest Oil Company before becoming the Henning Hotel. (Chuck Morrison Collection, CC WHC.)

Four

BUILDING THE TOWN

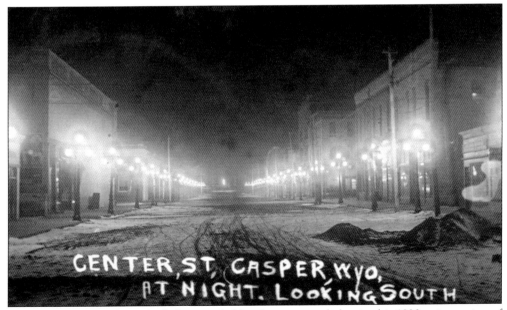

Downtown is aglow from the light provided by electric streetlights in this 1920s winter view of Center Street. Though the streetlights and boardwalks lent an air of modern comforts, this—one of Casper's busiest streets—still had yet to be paved. (Nicolaysen family.)

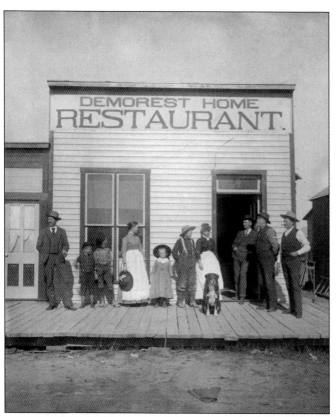

The Demorest Home Restaurant, Casper's first business, was built in 1888 to feed railroad workers. This photograph shows the building on Center Street, where it was moved from Old Town and continued to serve residents. (Frances Seely Webb Collection, CC WHC.)

Below is the Warner House, Casper's second hotel. This photograph is unique because the building only housed the Warner House for a short time. It was previously the Graham House and became the Adsit Hotel shortly after this was taken. The facing of the building appears to use two different materials, with brick on the left side and wood on the right. John S. Warner is seated and Theresa Pisacka is standing on the lower porch. (FCM.)

This busy 1907 scene shows many people at the unmarked building between Kimball's Drug Store and the Grand Central Hotel on the southwest corner of Second and Center Streets. The Grand Central Hotel, built in 1894, was Casper's first large hotel and a longtime fixture on Center Street. David Graham opened the hotel and later sold it to Hugh Patton. (Sheffner-Butler-Schulz Collection, CC WHC.)

The is the lobby of the Grand Central Hotel. Hugh Patton (far left) bought the hotel and also served as sheriff, constable, and, in 1909, as Natrona County's representative in the state legislature. Belle Patton stands in the doorway. Frank J. "Molly" Wolf, a rancher in the Bates Hole area, is seated at right; Bob Grieve, a rancher from southwest of Casper, is seated next to Wolf. Many ranchers and early oil prospectors stayed at the Grand, and it later hosted many celebrations and events. (Frances Seely Webb Collection, CC WHC.)

In 1894, James Smith purchased the Hotel DeWentworth, located at the northeast corner of Center Street and Midwest Avenue, and rebuilt on the same site, naming the new structure the Natrona Hotel. Like the Grand Central Hotel, the Natrona hosted celebrations, businesses, and travelers throughout its 40 years of existence. The Natrona was razed within a few years of when the photograph above was taken in the late 1930s or early 1940s. Below, three unidentified women prepare the dining room at the Natrona for Christmas. (Above, David Historical Collection, CC WHC; below, FCM.)

In the days before cars, blacksmiths played an important role in Casper society. In this 1890s image, the smith at the Svendsen Blacksmith Shop shoes a horse. Blacksmiths also worked on carriages and wagons, as seen at right. One of Casper's early fire hydrants is visible in the lower right foreground. (FCM.)

This c. 1900 scene shows the Grand Central Stable located on Second Street between David and Center Streets. Only two of the people are identified: Doc Rhoades (on the white horse in the center of the photograph) and John McClure (seated in the carriage at right). (FCM.)

The Richards & Cunningham Company building was on the southeast corner of Center and Second Streets. DeForest Richards and Alec Cunningham were speculators who set up dry goods stores in railroad towns such as Douglas and Casper. Richards was elected the fifth governor of Wyoming but died in office at the beginning of his second term in 1903. Cunningham, along with Charles King, helped start Casper's first bank, the C.H. King Bank Company; Cunningham also owned a ranch west of Kaycee. (Frances Seely Webb Collection, CC WHC.)

A popular business, the Richards & Cunningham Company owed some of its success to its merger with the C.H. King Bank Company, Casper's oldest bank. The bank was reorganized as Casper National Bank, survived the Great Depression, and is now part of First Interstate Bank. Both the Richards & Cunningham building and the original Casper National Bank building, which were on the same site, were destroyed by separate fires. (Frances Seely Webb, CC WHC.)

The Stockman's National Bank of Casper was chartered in 1903 with Charles Townsend as president and Percy Shallenberger as the first cashier. The bank was in the Townsend block at the northwest corner of Center and Second Streets. Townsend first started a clothing store in Casper, then became a successful banker and later built the Townsend Hotel. (Frances Seely Webb Collection, CC WHC.)

The interior of Stockman's National Bank is pictured above. Although the building suffered a fire in 1985, it survived, was restored, and now houses a number of businesses. (Casper Centennial Corporation Collection, CC WHC.)

This 1910 photograph shows a float traveling down Center Street in a Fourth of July parade. Some of Casper's early businesses are also pictured; they are, from left to right, the Hammond & Norton law office, the *Natrona County Tribune*, and the Webel Commercial Company. (FCM.)

The Webel Commercial Company, pictured above, was located at the northeast corner of Second and Center Streets and sold a wide variety of items including dry goods, groceries, guns, ammunition, hardware, fabrics, graniteware, sporting goods, tents, furnaces, and livestock feed. Charles C. Webel, founder of the store, was an early cowboy who later ranched east of Casper. (FCM.)

The *Tribune*, founded in 1891, was one of Casper's first newspapers. In 1897, Alfred Mokler purchased the paper and renamed it the *Natrona County Tribune*; Mokler published it for 17 years. The interior of the *Natrona County Tribune* office is pictured here around 1900. From left to right are Bertha Middleton, Mokler, and an unidentified man. (FCM.)

This c. 1900 panoramic photograph shows the west side of Center Street between Second Street and Midwest Avenue. The large building to the right is one of Casper's most elegant hotels, the Grand Central Hotel, which was built in 1894. The Grand hosted a variety of events in its dining room, including a ceremony in which Martha Kimball flipped the switch and lit the first electric

lights in Casper. The hotel lasted until the 1950s, when it was torn down and replaced with the Petroleum building. Kimball's Drug Store (just left of center in the picture) sold a variety of products ranging from pharmaceutical goods to jewelry. (FCM.)

As the population of Natrona County grew, residents decided that they needed a larger, more modern courthouse. The photograph above is from the June 22, 1908, ceremony in which Marion P. Wheeler, the Grand Master of Wyoming, laid the cornerstone for the new courthouse. The photograph below shows the completed building at the end of Center Street in February 1909. In 1940, this courthouse was torn down and replaced by the current courthouse, and Center Street was extended north across the railroad tracks, providing access to North Casper. (Both, FCM.)

The new courthouse was a Casper landmark for many years until it was replaced by the current courthouse in 1940. In this photograph, several county officials pose for a picture. Most of them are unidentified, but David Kidd, an early immigrant from Scotland who ranched north of Casper and pursued several business interests, is fourth from the right. William Grieve, who ranched southwest of Casper and was also a county commissioner, is second from the right. This photograph is possibly from 1909 or 1910 during one of Kidd's terms as county commissioner. (Frances Seely Webb Collection, CC WHC.)

This photograph shows the inside of Casper's first abstract and title company, an important business for the growing county. The map on the wall shows the date as 1918; during that time, these professionals would have been busy keeping up with the changing land and lease titles in the oil fields around Casper. (FCM.)

Casper's first refinery was partially converted into the city's first electric light plant in 1900. When completed, it furnished electricity to 20 businesses and 150 houses. Through the years, its capacity was increased to meet higher demands, and after it was destroyed by fire in 1918, it was replaced by a bigger facility. (FCM.)

This 1907 interior view of the Casper light plant shows some of the machinery used to produce electricity. Edgar Davis, the chief engineer and electrician for the plant, is standing to the right of the machine. The plant consisted of two engines, two dynamos, and one boiler. (FCM.)

In addition to maintaining the light plant, Edgar Davis was also in charge of maintaining the city's streetlights. In this 1907 photograph, Davis pauses during his work trimming the wick in the arc light at the corner of Durbin and First Streets. (FCM.)

Lou Taubert Sr. came to Casper in 1947 to open a branch of his family's ranch supply store, Taubert's Ranch Outfitters, at the corner of Midwest and Center Streets—the former location of the Natrona Hotel. The nighttime photograph below shows many of Casper's well-lit downtown businesses in the early 1950s, including Tripeny Drug Store and the Hotel Henning. Taubert's Ranch Outfitters later moved to its current location on Second Street. (Fred Thomason Collection, CC WHC.)

Marvin L. and Leona Bishop moved to Casper in 1892. After serving as Casper's postmaster for several years, Marvin Bishop entered the sheep business in 1898. In 1907, he commissioned this house in the new Capitol Hill district located east of downtown along Second Street. The home, built by William T. Evans, was a model for many of Casper's other fine residences. Bishop's children are standing on the porch. (Cadoma Foundation.)

First platted in 1894, the Capitol Hill district ran south of the railroad and expanded in subsequent years. It was named in hopes that the state government would relocate the territorial capital of Cheyenne to Casper, and while this idea resurfaced from time to time, it never gained traction. This 1925 image shows Johnson Brothers Grocery, which was located on Second Street near the beginning of the district. (Natrona County Pioneer Association Collection, CC WHC.)

Casper's first town hall had an unusual history. Built in 1890 by William T. Evans and Emanuel Erben, the hall stood between First and Second Streets on Center Street. Five years later, the building was repurposed as a "first-class opera house" and hosted concerts, dances, and various civic meetings. In 1910, it showed motion pictures and was called the Bell Theatre (for its bell tower). After only two years, a fire broke out, but while the bricks were damaged, they were still sound. The building was then converted to the Casper Fire Department Station One and the town council house. Fire struck the building again, damaging it beyond repair, and it was eventually replaced by other businesses along Center Street. (Frances Seely Webb Collection, CC WHC.)

Nathan Bristol purchased the first business lot in Casper at Second and Center Streets, and his store (pictured) supplied grain and other dry goods and was used as an early meeting place. It stood from 1889 to 1903, eventually giving way to the Townsend block. (FCM.)

Casper's first churches were simple buildings that gave way to larger stone and brick structures as the prosperity of their parishioners grew. The First Methodist Church, originally built in 1893, was replaced by this building at Durbin and Second Streets in 1906. It was then rebuilt on the same site in 1927. The church is the only one among Casper's early churches that remains in its original downtown location. (Nicolaysen family.)

St. Anthony's Catholic Church, built in 1898 at First and Center Streets, later moved to Seventh and Center Streets. The architectural firm of Garbutt and Weidner, who planned many of Casper's finest buildings in the 1920s, designed its replacement, which is at right in this image. The church remains at Seventh and Center Streets, but the building at left—the second city hall—was torn down after inspections revealed several structural flaws. (FCM.)

St. Mark's Episcopal Church is the first consecrated church building in Casper. The congregation built the first church in 1891, and this photograph shows a Thanksgiving service in the church around 1907. (FCM.)

Like the First Methodist Church, the congregation of St. Mark's built a larger structure, which is pictured in the center of this image, on its original grounds at Second and Wolcott Streets; this church was torn down in 1920. The steeple in the background belongs to the original wooden building from the 1890s. After this church was torn down, the congregation built another church at Seventh and Wolcott Streets, and the original 1890s building was moved to that site and stayed in use until it was moved to the county fairgrounds and renamed the Pioneer Church. (Nicolaysen family.)

Located at the corner of Center and First Streets, the Masonic temple was completed in 1914. The Masons have been a part of Casper's society since their organization as lodge no. 15 in 1893, the first benevolent organization in Casper. The building is pictured above under construction in 1914 and below shortly after completion. Since its completion, the lodge has been home to the Masons and their affiliated organizations, including the Order of the Eastern Star chapter no. four, organized in 1894. (Above, Nicolaysen family; below, FCM.)

MIDWEST BUILDING.

The Midwest building, erected in 1920 on the corner of Second and Wolcott Streets, was the largest office building in Casper at the time. It contained offices on the upper floors for a variety of companies and several businesses on the street level. The most well-known occupant of the building was probably the Wyoming National Bank, which opened in 1914. (McCleary family.)

Gladstone Hotel, Casper, Wyo.

Casper's wealth from the fast-developing oil industry necessitated new hotels for its growing population. Three fine hotels were built at First and Center Streets in quick succession: the Henning Hotel, the Gladstone Hotel, and the Hotel Townsend. In 1924, just a few years before Casper entered a bust period, the Gladstone went up at the northwest corner of First and Center Streets. Photographic postcards such as these helped promote Casper's wealth and opportunities for business while offering no hint at the imminent bust. The Gladstone's famous Crystal Bar and Ballroom (below) attracted Casper's high rollers and deal-makers and gave Casper's fine society a classy social venue. (Above, Western History Collection, CC WHC; below, FCM.)

Noted photographer Thomas Carrigen came to Casper in 1920 and quickly established himself in the booming town. His photographs form a wonderful record of the city, its businesses, and its social life. This ballroom scene at the Gladstone Hotel shows the glamour of the "Oil Capital of the Rockies." The hotels hosted bands and dances and broadcast the music played on local radio. (WSA.)

William Henning was a plumber who modernized several buildings in town. This picture shows the interior of his shop. (Chuck Morrison Collection, CC WHC.)

Hotel Henning.

Henning was awarded the contract to renovate the Midwest Hotel, located at the southeast corner of Center and First Streets. When the Midwest Oil Company decided to shut down the hotel, Henning claimed the building as payment for his bill. He then built the larger addition south of the hotel, renamed it after himself, and soon assumed the role of Casper's first millionaire. Whether he was the town's first millionaire or not, Henning was one of Casper's most flamboyant citizens who then built perhaps the grandest of all the houses in the area along Wolcott Street. (McCleary family.)

Claude Ayres first visited Casper from Republic, Kansas, during a 1919 boom. Impressed with the bustling town, Ayres quickly established a successful jewelry store (pictured) at 133 South Center Street. Imbued with the spirit of many pioneers of early Casper, his determination and hard work helped keep Ayres Jewelry going through Casper's busts. (Scott Ayres.)

Ayres moved the store to Second Street in the early 1960s and installed a street clock to advertise his new location. This photograph taken by Ken Ball shows the second Ayres Jewelry location; Ayres later moved the store to its current location, which is two doors east. (Scott Ayres.)

The Continental Oil Company brought a distribution center to Casper in the 1910s. The wholesale dealership at Midwest Avenue and Poplar Streets was across the road from the Standard Oil Refinery and supplied businesses, ranchers, and filling stations with refined products. Dana Van Burgh came to Casper in 1917 to operate the bulk plant, and he and his brother Shelby later took it over as commission agents. They later sold the business to Stanley Blower, who sold it to Homax Oil. (Dana Van Burgh Jr.)

One of the service stations supplied by the Continental Oil Company was Wyatt Filling Station at West Yellowstone and Walnut Streets. George Wyatt (standing at right) built the filling station in 1920 with his brother, Henry. The girl at left is Margaret Spaulding, while the girl in the center is unidentified. Spaulding lived in an apartment above the filling station with her family during the early 1940s, which was when this photograph was taken. (Kukura-True Collection, CC WHC.)

The Coliseum Motor Company opened in 1913 and sold Dodge automobiles to Casper's elite. Their building also served as a dance hall, a skating rink, and a boxing arena and was central to the early Casper social scene. As the popularity of automobiles grew, the blacksmiths of Casper were quickly put out of business. (WSA.)

Dr. Homer Lathrop was one of Casper's well-trained early surgeons. After serving as the surgeon during the construction of Pathfinder Dam, Lathrop moved to Casper and began a thriving medical partnership with Dr. Marshall C. Keith. Lathrop decided to build two private hospitals on Durbin Street. The one at Durbin and Eighth Streets (pictured above) was a clinic shared by multiple doctors with different specialties. (Nicolaysen family.)

Lathrop's other hospital, located at Durbin and Sixth Streets, was a women's and children's hospital dedicated to specialized care. Both hospitals were recognized as progressive examples in the Rocky Mountain area. Lathrop was very interested in new medical research and technology and brought an incubator to Casper after his wife, Jean Brooks Lathrop, lost twins in utero after a fall. At left, a nurse and a girl identified as Abby pose outside the women's and children's hospital. (Nicolaysen family.)

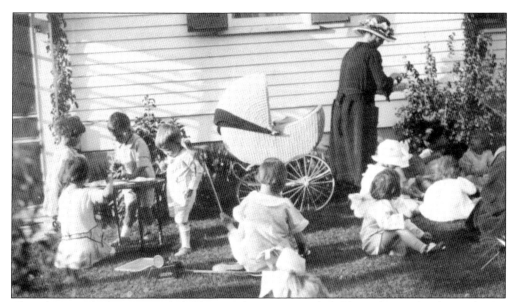

This photograph shows several children at the women and children's hospital. Ultimately, Dr. Homer Lathrop's health could not sustain his many enterprises and medical calls around the county, and his private hospitals closed in the late 1920s. He died in 1935. (Nicolaysen family.)

In 1909, the state legislature voted to fund a branch of the Wyoming General Hospital in Casper with the requirement that the town donate the land for the building. This proved to be the easiest part of the building's construction. After much legislative wrangling, the hospital opened its doors on November 1, 1911. Ownership was transferred to Natrona County in 1922, and in 1986, the Wyoming Medical Center began leasing the county-owned facilities. (Nicolaysen family.)

This appears to be an early photograph of the Grant Street Grocery before it was remodeled; unfortunately, the trees obscure the sign. The grocery has been a fixture of residential Casper for many years. Most neighborhoods had a grocery; in 1924, Casper had more than 70 grocers. A sign in front of the store advertises Palms Ice Cream from the Palms Florists and Ice Cream Manufacturers in downtown Casper. (FCM.)

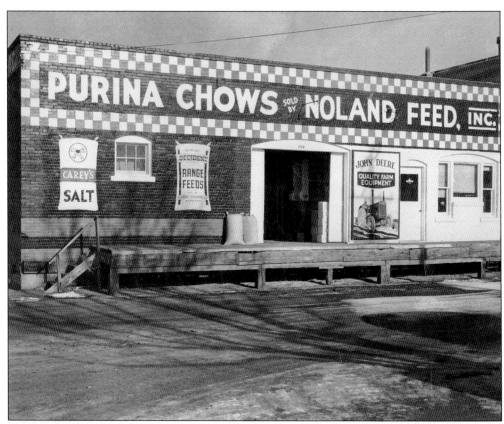

Brothers Roscoe and Howard Noland started Noland Feed around 1925. The first store was located on Midwest Avenue, but when it was destroyed by arson in 1950, the Nolands bought out Casper Feed and moved Noland Feed into its current location (pictured) on Industrial Avenue. Neal Schlager purchased the store in 1972 after spending many years farming and gaining experience with seed and feed alongside the Alcova Irrigation project. (Schlager family.)

Replica of Fort Caspar
rebuilt on the original site
3 miles west of Casper Wyo.

The original Platte Bridge Station became a small army outpost in 1862 to protect settlers and the telegraph line. After Lt. Caspar Collins was killed in July 1865 in a skirmish with Native Americans near the fort, the army renamed the post in his honor. Due to a clerical error, the fort was mistakenly named "Fort Casper," and the city was eventually named after this misspelling. The mistake was corrected when the Fort Caspar Museum (pictured above and below) was reconstructed on the original site in 1936. (Above, FCM; below, Trumbull family.)

The Sandbar District was perhaps the most notorious part of Casper. Since it was located in a meandering loop along the North Platte River, the area became prime real estate for Casper's poorer population due to its poor drainage control. It also evolved into the red-light district of Casper despite numerous attempts to control prostitution and gambling. These two photographs show views of the cribs in the Sandbar District before laws finally closed the houses of ill repute in 1942 due to the proximity of the Casper Army Air Base. Urban renewal projects in the 1970s led to the replacement of most of the buildings, including the infamous cribs. (Above, Walter Jones Collection, CC WHC; below, Trumbull family.)

Five

SCENES IN AND AROUND TOWN

STREET PARADE
CASPER WYO. JULY 4TH 1912

This view of the Fourth of July parade in 1912 was captured from the top of the second courthouse as the parade moved north along Center Street. A flag is flying above the Bell Theatre at right. Several of the houses in the South Wolcott Historical District are visible in the background, including Martin Gothberg's (left rear), Patrick Sullivan's (center), and A.J. Cunningham's (right rear). Part of the switchback road to Casper Mountain is clearly visible as a large horizontal "V" in the upper left corner of the picture. (FCM.)

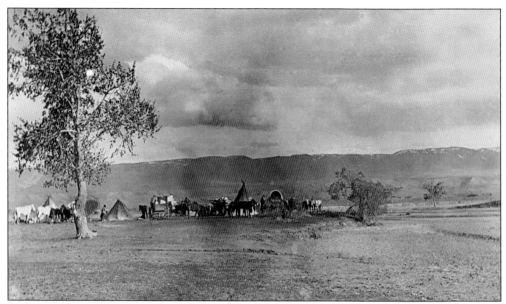

This c. 1890 photograph shows an Indian camp along the North Platte River near present-day Casper. Even after the town began to flourish, Indian camps were set up near Casper in order to trade, always drawing local attention. (Doug Cooper.)

This dynamic scene outside the Hotel DeWentworth on Center Street was titled "Indians Entertaining Casper Palefaces in 1894" by Alfred J. Mokler in his book, *History of Natrona County*. Although the tribes had lost the Powder River country north of Casper, several groups continued to pass through the area to stop at Casper's busy supply stores. (Nicolaysen family.)

This photograph shows an unidentified group of white settlers posing with a group of Indians in front of a teepee near Casper in 1894. Tribes commonly seen in the area included the Gros Ventre, Shoshone, Arapaho, and Sioux. (FCM.)

This 1890s photograph shows four unidentified Indians walking down the boardwalk on Main Street. Such scenes were common, because trade flourished between white settlers and Indian tribes. (FCM.)

This photograph shows a mud wagon traveling on the stage line toward the construction of Pathfinder Dam. The stage carried passengers and small amounts of freight. Designed by the then-new Bureau of Reclamation, the Pathfinder Dam was the first large project of its kind in the county. (FCM.)

String teams were commonly used to transport freight and goods from Casper to towns and worksites not connected to a railroad, including the Pathfinder Dam project. Some of the loads consisted of several wagons pulled by one string team, such as this 26-horse string team passing the Schultz Blacksmith Shop (the dark building in the center) around 1900. (FCM.)

Dr. Homer Lathrop, a graduate of Rush Medical College, worked as the surgeon at the construction of Pathfinder Dam. After the project was complete, he settled in Casper, opened his own practice, and built two private hospitals. Whenever he was needed, he traveled to ranches and oil fields. (Nicolaysen family.)

Begun in 1906 and completed in 1909, Pathfinder Dam was the first dam on the North Platte River; it regulated flooding and made large-scale irrigation projects possible. (Nicolaysen family.)

1600-PATHFINDER CAÑON - CASPER, WYO.

1616- PATHFINDER DAM
CASPER, WYO.

Funded in part by a consortium of Nebraska financiers, the Pathfinder Dam was required to allocate a large portion of its reservoir for use downriver. When it was completed, Pathfinder was the largest dam of its kind in the country. The 100th anniversary of the dam was in 2009, and it still plays an important role in water management on the North Platte River. Pathfinder Reservoir also provides numerous recreational opportunities. (Both, Nicolaysen family.)

Although no precious mineral mines prospered for long in Natrona County, coal mines enjoyed modest success, providing coal to local distributors primarily to heat private homes and businesses. This 1909 photograph shows the tipple of the B.B. Brooks Mine near the Big Muddy Creek southeast of Casper. The mine was named after prominent local rancher Bryant B. Brooks. (FCM.)

Early Casper residents witnessed several "strikes" and "rushes" of precious minerals on Casper Mountain. The mountain was surveyed and mineral samples were assayed. Though minor amounts of gold, silver, and other metals were discovered, no successful mine was ever established. The short-lived town of Eadsville, founded by Charles Eads, did not survive the mining craze, but it later became a camp for victims of tuberculosis. By the time this photograph was taken in the 1940s, the town had been abandoned. (Trumbull family.)

This 1930s photograph shows the Indian Ice & Cold Storage Co. and three of the company's trucks preparing to depart to deliver ice to Casper homes and businesses. Before household refrigerators became common in the 1940s, residents relied on ice deliveries. The Indian Ice Company still serves Casper businesses today. (WSA.)

Milkmen often delivered milk and other dairy products from local dairies to homes and businesses. This Casper Dairy Products Inc. truck is parked outside Natrona County High School, and the milkman is carrying empty bottles to the truck. Full milk bottles ready for delivery are visible in the truck's front window. (WSA.)

This photograph shows one of the Salt Creek Transportation Company's motorized coaches preparing to depart Casper. These coaches, which featured canvas sides that could be rolled down in the event of inclement weather, were a great improvement over the old horse-drawn stages. (FCM.)

The Casper Motor Bus Line Company began operations in 1923 and served the Casper community with public transportation until 1958. This photograph shows one of the first buses run by the company—the bus fare was 5¢. (FCM.)

Local Indian tribes participated in early Casper parades. This photograph from the early 1900s shows one group preparing for the parade in front of Florence Hardware (the building at left with the dark sign) on Center Street. (Robert Kidd.)

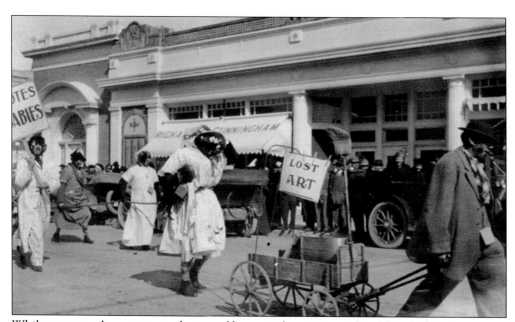

While some parade participants showcased humor, others attempted to deliver political messages. This group marching in the 1916 Shriners parade seems to be protesting the progressive women's rights movement, drawing attention to the "lost art" of a washboard and broom. (FCM.)

This float in the 1912 Fourth of July parade promoted W.F. Henning Plumbing and Heating. Floats in this time period were often lavish affairs, especially compared with some of the floats of today. Parades continue to be popular events in Casper. (FCM.)

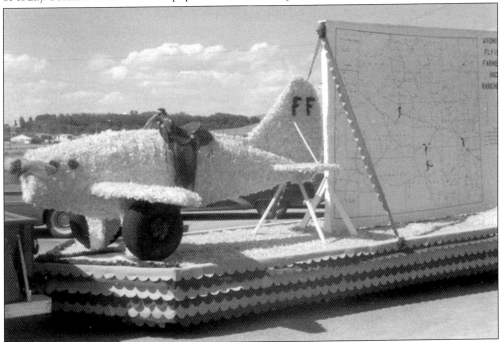

The Wyoming Flying Farmers and Ranchers presented this float for a 1950s Casper parade. This group consisted of agriculturalists who owned airplanes and met for regular meetings across the state. Because of the vast distances between ranches and towns, many Western ranchers became avid pilots. (McCleary family.)

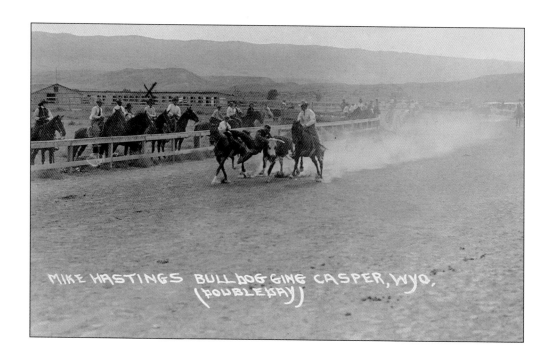

MIKE HASTINGS BULLDOGGING CASPER, WYO, (DOUBLEDAY)

Rodeos evolved from ranch work and showcased precise—if not always useful—skills. Casper had a few racetracks and rodeo grounds, including a large stadium near Poplar Street. Ralph Doubleday, the famous rodeo photographer, made Casper part of his circuit. (Above, McCleary family; below, FCM.)

ROMAN STANDING RACE, AMERICAN LEIGON STAMPEDE, CASPER, WYO, (DOUBLEDAY) (LOOK AT THAT CROWD)

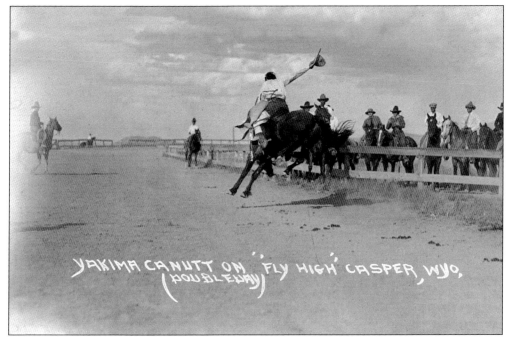

The famous Yakima Canutt also visited Casper's rodeos. Canutt spent his early life performing in rodeos before moving to Hollywood and earning his living as a stunt artist. Perhaps his most famous scenes are from the beloved 1939 movie *Stagecoach*. (McCleary family.)

Many rodeo contestants were local cowboys who could ride with the best. This is Slim Buckingham, who was born in 1896 and came to Casper at age 14. Buckingham worked on a number of Natrona County ranches, including Willow Creek, Buffalo Creek, and the JE Ranch. (John Buckingham.)

A large crowd gathered outside the *Tribune* Building (out of frame at right) on Second Street in the late 1930s for the World Series. In the time before television, and with radios a luxury during the Depression, the *Tribune* entertained Casperites with a large sign hung from the building that was updated with each play. (Western History Collection, CC WHC.)

Established during the Great Depression to provide jobs, the Civilian Conservation Corps (CCC) worked on many projects around Casper, including a variety of projects on Casper Mountain. Like the rest of the nation, Casper was hit hard by the Depression as demand for its commodities faltered. Several federally-funded projects benefited the town and the area, including the present-day courthouse on A Street and Center Street. (Western History Collection, CC WHC.)

During Prohibition in the 1920s, moonshining and bootlegging were common in the Casper area. Law enforcement performed numerous raids, seizing thousands of gallons of alcohol and a large amount of equipment. The alcohol was usually poured into the North Platte River, while the stills were often hacked apart using axes under the witness of the Women's Christian Temperance Union. (Chuck Morrison Collection, CC WHC.)

Skiing has been a Casper tradition since the first ski trails were cleared on Casper Mountain by the CCC in the 1930s. In the 1950s, the Casper Mountain Ski Club formed the Central Wyoming Ski Corporation and began discussions about a formal ski resort in the area, which led to the creation of the Hogadon Ski Area in 1959. (Western History Collection, CC WHC.)

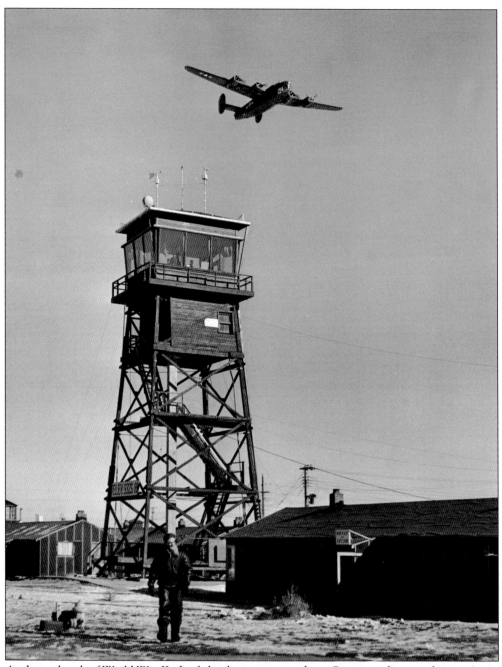

At the outbreak of World War II, the federal government chose Casper as the site of a new Army air base. The base, which was completed in 1942, contained four runways of varying lengths and hundreds of buildings. Construction of the base provided thousands of jobs and a much-needed economic revival for Casper. The Casper Army Air Base operated for two and a half years. (Chuck Morrison Collection, CC WHC.)

Between 1942 and 1945, thousands of servicemen were stationed at or passed through the Army air base. This photograph shows a group of servicemen marching down one of the streets on the base in front of the numerous barracks. (Chuck Morrison Collection, CC WHC.)

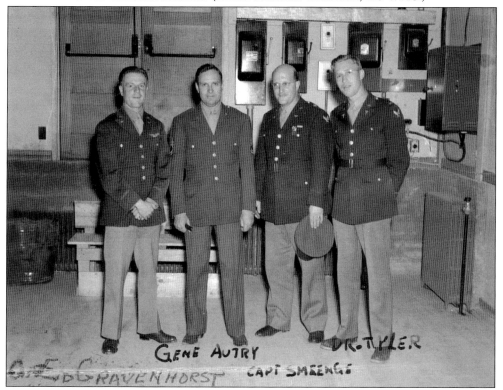

This 1943 photograph shows a group of officers at the Casper Army Air Base. From left to right, they are Capt. Ed Gravenhorst, Gene Autry, Captain Smeenge, and Dr. Tyler. Autry was a famous Western actor and singer who joined the armed forces to do his part when the war broke out; he served as a flight officer. (FCM.)

In early January 1949, a blizzard hit the Great Plains, bringing cities to a standstill. Several feet of snow fell within days. In Casper, residents were trapped for several days. This picture shows a young Sandra Leik at Seventeenth and Oakcrest Streets as the city tried to recover. (Ted Leik.)

Ranchers were isolated, and cattle and sheep drifted far from their home pastures during the storm. Livestock starved or were snowed under. The Casper Army Air Base began running hay drops to feed stranded livestock, and several rancher pilots flew with the Army pilots to direct them to various ranches around the state. Ground crews, like this one on Hat Six Road east of Casper, worked to clear roads that led to distant ranches. (Chuck Morrison Collection, CC WHC.)

Six

EDUCATION AND SOCIAL LIFE

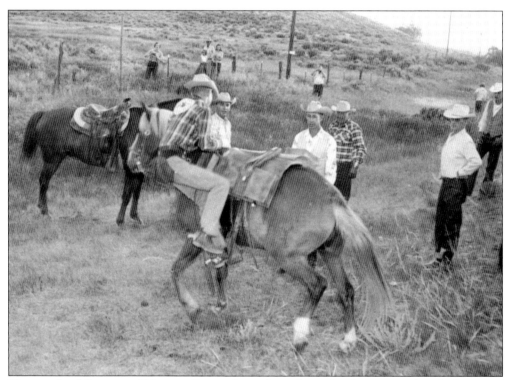

The people of Casper and Natrona County have always been closely connected to the history of the area. This 1960 photograph shows the 100th anniversary of the Pony Express rides. Ranchers near Sweetwater Station, southwest of Casper, took part in the ride, including Bernard "Bunny" Grieve, who is mounting the horse in the foreground. Standing in the foreground behind Grieve and the horse are, from left to right, Norman Park, Jimmy Grieve, and Bernard Sun; the rest are unidentified. The National Pony Express Association began anniversary rides in 1978, with riders switching mail-carrying saddlebags, or mochilas, at each station. (Chuck Morrison Collection, CC WHC.)

The frontier town quickly organized a school in 1891. This photograph shows many of Casper's early teachers, including, from left to right, (first row) Bertha Geotzman Jewett, Althea Jones, Mrs. Matheney, Emma Yard, and Edith Evans; (second row) Edna Smith, F.E. Matheney, Nora Crow, E.M. Childs, and Mary Craig. F.E. Matheney served as principal and superintendent of schools for several years. This photograph is probably from 1900, 1901, or 1902. (FCM.)

Mary Craig, a teacher at the public school, was married to Reverend James Craig of St. Mark's Episcopal Church. She is pictured here with her kindergarten class at the church. (FCM.)

In this c. 1900 image, students have just arrived at the schoolhouse from surrounding ranches. In the era when travel to Casper could take as long as a day, some ranching families sent children to the one-room schoolhouses spread throughout the county, while some children boarded with families in town. This District No. 11 school was along present-day Hat Six Road. (McCleary family.)

This photograph shows the interior of the District 11 Schoolhouse. Students from all grades would learn in the same room from one teacher. It was common for children to go to the local schoolhouse until high school, when they would live in a boardinghouse in Casper. The only student identified in this photograph is Lena Brooks, who is seated second from the right. (McCleary family.)

Casper's first public school building was completed in 1891 at the corner of Durbin and First Streets. This c. 1900 postcard shows schoolchildren and teachers posing in front of the building. (FCM.)

Central High School was built in 1910 along First Street in downtown Casper. The school was later renamed Washington School and expanded to accommodate the rise in student population, but the commercial development of the downtown area eliminated the need for a school in that location. The Wyoming National Bank purchased the building and tore it down in the 1960s to make way for the bank building at the corner of First and Durbin Streets. (Nicolaysen family.)

1592 - NEW HIGH SCHOOL
CASPER, WYO.

In 1914, a new high school was built for the town of Casper. It served until 1924, when the county's growing population led to it being demolished and then replaced, on the same site, with Natrona County High School. (Nicolaysen family.)

In 1924, construction began on Natrona County High School under the direction of Arthur Garbutt. A lasting symbol of Casper, the school houses Wyoming's first indoor swimming pool, the International Thespian Society Troupe One, and the second-oldest Junior ROTC in the country. (FCM.)

The Natrona County High School science club posed for this photograph with some of their projects in 1922. Some of the group members are identified as, from left to right, (first row) Roy Frisby (at far left); (second row) Robert Ward, Edna Harris, unidentified, Alice Blodgett, unidentified, Kathleen Hemry, Charles Hemry, and unidentified. (FCM.)

The NCHS women's basketball team is seen here in 1922 with their trophy. The team members are, from left to right, (first row) Marion Noyes, Florence Eastman, and Wilma Paterson; (second row) Alice Clayton, Kathleen Hemry, and Frances Davis. (FCM.)

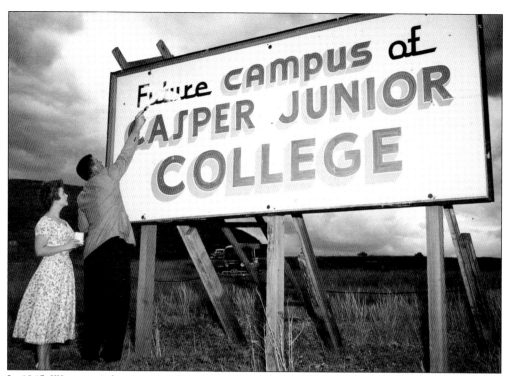

In 1945, Wyoming's first junior college opened on the third floor of Natrona County High School. It remained there until 1954, when construction began on the current campus of Casper College, which is at College Drive and Casper Mountain Road at the end of South Wolcott Street. The photograph above shows Gaynell Logan (left) and Gerald Radden painting through the word "future" on the campus location sign. The photograph below captures Jackson King (left) and Mary Lee Griffith (right) digging the first shovelful of dirt while a crowd watches at the groundbreaking ceremony in 1954. (Both, College Relations Collection, CC WHC.)

This 1911 photograph shows the Casper Concert Band. The members included, from left to right, (first row) Nora Banner, Margaret Banner, Herbert Bogue, John Trevett, and Otto Rhoades; (second row) Sam Conwell, Ray Bryan, Willie Lilly, George Lilly, Wilton Weeks, Wilber Foshay, and Frank Bogue; (third row) Jack Healy, Tom Spears, Harold Banner, Clyde Weeks, and Henry Bayer. (FCM.)

This 1908 photograph shows the Casper baseball team. The team included, from left to right, (first row) John Trevett, Pierce Smith, Ed Roland, Wilton Weeks, and Alfred Clowery; (second row) Bill Cobb, Victor Mokler, Coach Huffman, Vern Mokler, Eugene Dunn, and Ray Rhodes. (FCM.)

Casper Fine Arts Club.
Feb. 19, 1926. - Carrigan Photo.

The Fine Arts Club, founded in 1926, is one of Casper's longest-running social clubs. In conjunction with other social groups, the club was able to buy the former Midwest Oil Company building at Fifth and Wolcott Streets. Midwest had used the building to host visiting executives, but the clubs hosted gatherings and presentations there. The Fine Arts Club's founding statement reads: "Organized for the purpose of studying the fine arts in all their branches and for the purpose of bringing to Casper exhibits of art." The lines on the photograph identify Clementina Evans Nicolaysen, a founding member of the Fine Arts Club, and her husband, Peter C. Nicolaysen. (Nicolaysen family.)

The Natrona County Pioneer Association formed in 1901 and, at first, restricted membership to those who settled in the area before 1895. This was later relaxed to incorporate more members with deep roots in the county. Members were influential in historic preservation around town, including saving Casper's oldest church and funding several commemorative monuments and plaques around the county. This 1932 photograph shows the ladies of the association in front of the Bryant B. Brooks mansion on Twelfth Street. (FCM.)

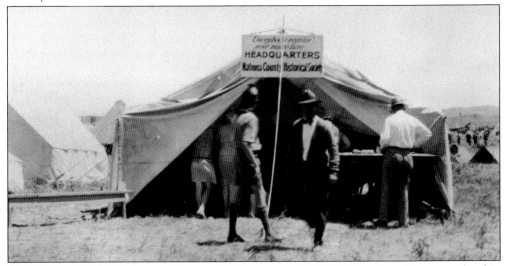

The Natrona County Historical Society, which was organized in 1925, endorsed open membership for all those interested in the history of Natrona County and Casper. Officers and board members included a number of Casper pioneers, including Thomas Cooper, the group's first president; Bryant B. Brooks, vice president; and Wilson S. Kimball, board member. This membership sign-up tent was placed at Independence Rock during the 1930 Covered Wagon Centennial, an event celebrating the 100th anniversary of migrations along the trails; the Boy Scouts of America held a ceremony and installed a commemorative plaque at the rock. (Gerald Sherratt Collection, Southern Utah University.)

Seven

LIFEBLOOD OF A CITY

This 1925 photograph offers a view of the tanks used at the Standard Oil Refinery, demonstrating the scale of the oil industry in Casper. By 1925, Casper had been established as the "Oil Capital of the Rockies" and boasted that more oil was shipped out of the city by rail than from any other city in the world. (FCM.)

The first oil well to hit pay dirt in the Salt Creek area—40 miles north of Casper—was named Shannon No. 1 after its financier, Mark Shannon. It was completed in 1890 after Shannon encountered numerous problems during drilling. The oil from this well was tested and was found, much to the surprise of everyone involved, to be the highest-quality oil discovered to date. This discovery soon led to the growth of the Salt Creek Field and the rise of Casper as the center of the country's oil industry. (Casper Centennial Corporation Collection, CC WHC.)

Mark Shannon's Pennsylvania Oil Company built the first oil refinery in Casper in 1895. Located south of the railroad, near Center Street, the refinery processed 50 to 100 barrels of crude oil per day into valve and engine oil. These buildings were later converted into Casper's first electric light plant. (FCM.)

From the time the first well was drilled in 1890 until the first oil pipeline was completed in 1922, oil had to be transported from the Salt Creek Field to Casper by string teams of up to 24 horses. The teams would pull supplies and equipment from town and return with a load of oil for the refineries. This photograph shows one such string team hauling oil to Casper in the 1890s. (FCM.)

In 1922, the Central Pipeline Company completed construction of a pipeline to carry oil directly from the wells in the Salt Creek Field to the Texaco Refinery of Casper. By 1923, the company had laid several hundred miles of pipe connecting all of the refineries to the Salt Creek Field. This construction crew is working on one such line near the North Platte River. (Frances Seely Webb Collection, CC WHC.)

The Midwest Oil Refinery is pictured above around 1912. Midwest Oil Company was one of the largest early oil companies, with many properties in the Salt Creek Field. It built several pipelines to transport oil to this refinery near present-day Mills. Pictured below are, from left to right, Oliver Shoup, the president of Midwest Oil and, later, the governor of Colorado; H.M. Blackmore; Edgar Davis; Newt Wilson; and Harry Rathburn. (Both, FCM.)

This photograph shows the Standard Oil Company ambulance stationed at their refinery. Standard came to Casper in 1912 and bought land near Poplar Street (under an agent's name) from Joseph M. Carey in order to build a refinery. Standard was one of the richest corporations in the nation at that time, and its managers knew Carey would likely charge a high price for his land if he knew who was buying it. Standard (later Amoco) was in business in Casper until the 1980s. (WSA.)

By 1914, construction was completed on what was possibly the largest oil refinery in the world, the Standard Oil Refinery. In 1922, more than one million barrels of crude oil were processed into gasoline and kerosene at this refinery. This postcard gives an indication of the immense size of the plant. (McCleary family.)

HJORTH OIL CO'S GUSHER. SALT CREEK, WYO.

Many smaller, independent companies—such as Hjorth Oil Company—also found oil in Salt Creek. As oil continued to be developed near Casper at Ervay, Oil City, Glenrock, and Parkerton, these independent companies sold their oil to the large refineries as well. (Nicolaysen family.)

Scandal broke out near Casper's oil fields in the 1920s. In 1922, Albert Fall, the US Secretary of the Interior, bypassed the competitive bidding process and engaged in a secret deal to lease the federally owned petroleum reserve at Teapot Dome to Harry Sinclair, an oil executive. Both men eventually went to prison for their roles in the deception. (FCM.)

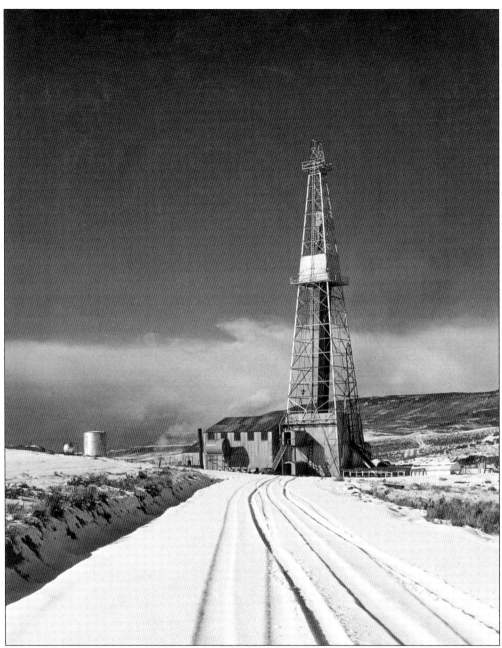

Photographs and postcards of gushers helped draw investment throughout the 1920s and 1930s, but this photograph from the 1940s shows a quieter scene. It was taken by Ken Ball, a photographer who settled in Casper after World War II and was employed by several oil companies. (Ken Ball Jr.)

Casper residents witnessed the spectacle of several oil tanks ablaze on June 17 and 18, 1921. The fire, started by a lightning strike, spread to seven oil storage tanks on the Midwest Oil Company tank farm, burning more than 500,000 barrels of oil. Thousands of Casperites traveled to the tank farm to watch the efforts to prevent the fire from spreading to other tanks. (Western History Collection, CC WHC.)

This photograph offers another view of the blaze at the Midwest Oil tank farm just west of town. The blaze resisted all firefighting efforts, lasted 60 hours, and was the most destructive fire in Natrona County up to that time. (FCM.)

Eight

WORKING THE LAND, FEEDING THE PEOPLE

The sheep wagon, which is considered a Wyoming invention, provided a home on wheels for shepherds tending to their flocks. This precursor to a modern RV contained a bed, a cook stove, a table, and storage for food and supplies, enabling a shepherd—and sometimes his family—to live comfortably while roaming the Wyoming prairie. Ranches often had as many as 20 wagons like this one from the 1930s. (McCleary family.)

An early photograph of the CY ranch shows a well-planned series of ranch buildings. Joseph Carey and his brother R. Davis had three large ranches along the North Platte River between Bessemer Bend and Douglas. Carey's business acumen and early settlement gave him claim to the land on which Casper was developed. (Frances Seely Webb Collection, CC WHC.)

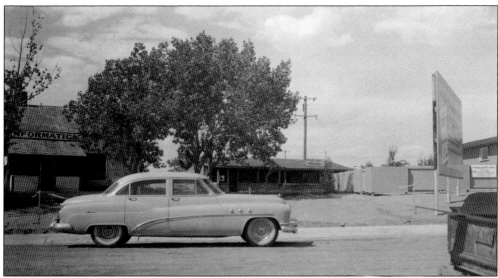

Over time, Carey sold much of his ranch grounds, and finally, after his death, the ranch passed to Harry Yessness, a clothing salesman who developed the remaining property into Casper subdivisions such as the Westridge addition, pictured here in the 1940s. The small wooden building in the center background was the last to stay on the original ranch grounds, although some of the barn buildings were moved to other residences in Casper. (David Historical Collection, CC WHC.)

Joseph Carey's ranches included the CY; the C Lazy Y, which was east of the Natrona County line west of Glenrock; and Careyhurst, which was along Boxelder Creek, where he had a beautiful stone house built for his visits to the area. This scene shows a group of CY cowboys beginning a roundup near Casper. Carey ranched in the heyday of the open-range cattle era, when cows were turned out with little winter feed and attention. Carey survived the terrible winter of 1886, which put many of his neighbors out of business, enabling him to buy up other ranches such as the Goose Egg, which he bought from the Searight brothers, Gilbert and George. Perhaps Carey's greatest legacy—apart from his political machinations as a US senator and a governor of Wyoming—is that many cowboys who worked for him were able to begin their own ranches after his empire began to fade. (David Historical Collection, CC WHC.)

Bryant B. Brooks arrived in the Casper area in 1881 after roaming the West while trapping and working for ranches in Colorado and Wyoming. In 1882, Brooks traded six No. 4 beaver traps and a sack of flour for a cabin on Muddy Creek along present-day Hat Six Road. From this humble start, Brooks created one of the largest cattle ranches in central Wyoming, the V Bar V. In addition to the V Bar V, Brooks also owned the Banner Ranch, the Buzzard Ranch, and the Stroud Ranch. This early photograph of the V Bar V ranch is from the 1890s. (McCleary family.)

In 1905, Bryant B. Brooks purchased the Banner Ranch, which was originally homesteaded by Harold Banner. Banner moved to Casper and became involved in several organizations, including the Masons, the fire department, and the Rotary Club. Brooks later sold this ranch to his daughter Lena and her husband, Marion McCleary. The ranch, which contained both sheep and cattle before becoming a strictly beef operation in the 1940s, is still owned and operated by the McCleary family. This 1933 photograph is of the ranch headquarters at the base of Banner Mountain. (McCleary family.)

The Goose Egg Ranch, established by Gilbert and George Searight, was 15 miles west of Casper. The ranch house became famous as the setting for the book *The Virginian*, written by Owen Wister in 1902. It soon became a popular destination for tourists, who slowly destabilized the structure by chipping "souvenirs" out of the walls, eventually leading to the 1951 demolition of the building due to safety concerns. (FCM.)

This 1930s image shows the Gothberg Ranch buildings. Martin Gothberg came to Wyoming in 1885, cowboyed for Joseph Carey and the Searight brothers, and assisted in building the Goose Egg house. He later homesteaded along Casper Mountain just west of the CY ranch. Gothberg began sheep ranching in 1893, and his ranch grew to 60,000 acres. After his death in 1947, his children ran it until selling it in 1961 to Earl Hanway, who subdivided much of it. These buildings, along with the surrounding acres, are still in use today as a cattle ranch. (Roy and Susan Littlefield Haines.)

Dr. Homer Lathrop bought a dairy along Elkhorn Creek to provide fresh milk for his private hospitals. His other enterprises included a mink farm and a chicken farm, though it is unknown if the products of these farms were also dedicated to the hospitals. The Lathrop dairy barn, pictured above in the 1920s, still stands near Casper. (Lathrop-Nicolaysen families.)

Haying for cattle was a relatively unheard-of concept in the early 1880s, and older cowmen scoffed at the young ranchers "wasting" time and effort to improve hayfields for anything other than horses. Those older ranchers changed their tunes after the winter of 1886–1887, when heavy snow caused great losses of livestock and put many of the large ranches out of business. After that winter, large-scale haying became a regular practice on central Wyoming ranches. Above, a horse team cuts hay on the Banner Ranch. Below, ranch workers stack hay on the V Bar V in 1909. (Above, McCleary family; below, Nicolaysen family.)

Perhaps the greatest innovation in American agriculture was the tractor. Local ranchers were quick to adopt the new technology, which increased productivity while necessitating fewer laborers. This c. 1930 image shows Marion McCleary operating the first tractor owned by the Banner Ranch. (McCleary family.)

John B. Kendrick was a Sheridan rancher and a US senator who represented Wyoming. As senator, Kendrick was able to legislate the Alcova Irrigation Project, a canal running from the Alcova Reservoir to lands northwest of Casper, which provided irrigation for many farmers and ranchers. The Alcova Project (sometimes called the Kendrick Project) was a Depression-era public works effort that created the irrigation infrastructure that enabled many people in Natrona County to farm. (Earle G. Burwell Collection, CC WHC.)

A string team operated by teamster Charles McFarland is pictured here in 1896 at the corner of Second and David Streets in front of John Blessing's blacksmith shop (center) and Castle's Livery (far right). The wall of the blacksmith shop contains an advertisement for the Lemen Brothers Circus; advertisements like this were put up well before the show came to town. (FCM.)

A trip to the circus was always a memorable event for rural children and often resulted in the children creating their own versions of the circus tricks when they returned home. In this 1933 photograph, siblings Mick (left), Lenora (center), and Bryant "Cactus" McCleary show off their own tricks after a trip to the circus. (McCleary family.)

Aviation was an important part of rural life in the 1950s. Many farmers and ranchers owned airplanes and used them not only to assist with work but also to carry agricultural families on vacations and to local barn dances. In this 1950s image, Bryant "Cactus" McCleary poses with his single-engine Cessna airplane. (McCleary family.)

Aviation was not always a safe activity in early Casper, as shown in this 1930s photograph of an airplane crash near the Casper packing plant. Accidents like this drew hundreds of onlookers; the crash site had to be roped off so that the airplane did not fall out of the tree and onto a bystander. (McCleary family.)

In this undated image that may be from the 1920s, sheep graze on Casper Mountain. Sheep ranching was the first significant industry in the Casper area, and the demand for fine wool was met by several immigrant ranchers. Sheep were well suited to the area, as well as cheaper to feed and able to thrive on rougher terrain and poorer grasses, and Casper boomed thanks to their wool. Although the industry faced setbacks in the early 1910s due to weather and a poor market, sheep continued to provide livelihoods for many ranchers. After World War II, the number of employable shepherds dwindled and there was an increase in losses to predators, which threatened the industry. (Nicolaysen family.)

This 1896 image shows a load of wool coming into Casper's wool warehouse. Casper shipped large amounts of wool throughout the early 1900s, and many of the large residences built in Casper around that time were paid for because of wool. (FCM.)

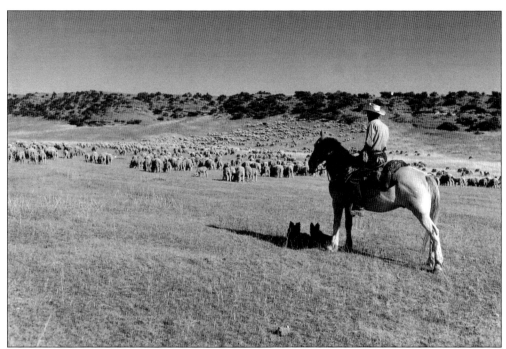

A sheep and cattle ranch since the early 1890s, Willow Creek Ranch (above), located north of Casper, was a favorite setting for photographer Ken Ball. In this photograph taken by Ball, a herder is trailing sheep to the Bighorn Mountains. (Ken Ball Jr.)

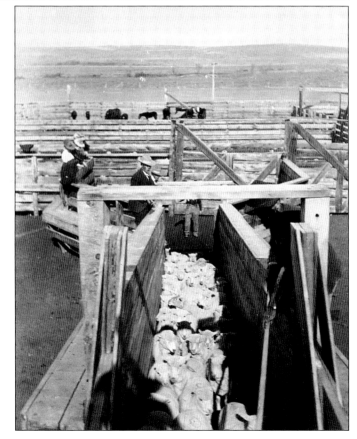

These sheep are being loaded onto railcars to be shipped to market. It is not known which Casper-area pens are seen here, but they are likely near Mills. (Doug Cooper.)

In these large shearing pens located west of Casper, several shearers are using hand blades in an era before electric clippers were widespread. The fleece was packed in large burlap bags and either transported to a wool warehouse or shipped directly from a nearby rail station. The bags were often compressed by young children who would climb into the bags to stomp the fleece. These bags are marked "C.H. King." King was Pres. Gerald Ford's grandfather, and he set up many banks and businesses along the route of the Fremont, Elkhorn and Missouri Valley (FE&MV) railroad. (CC WHC.)

After shearing, sheep were forced through a shallow trough made of wood or, later, concrete. The trough was filled with various ingredients that would soak the skin and wool of the sheep and kill pests such as flies and lice. Here, several Casper schoolteachers join in the fun. (Doug Cooper.)

Sheep provided the economic backbone for many of the early ranches in the area. The animals were sheared in the spring, and the wool was shipped to the wool warehouse in Casper and then taken by rail to markets across the country. In the 1890s, wool was carried to Casper on the back of horse-drawn wagons in caravans such as the one pictured above, which was traveling along present-day Hat Six Road. Trucks eventually replaced wagons, but farmers still hauled wool in large sacks, as shown in the c. 1940 image (below) from the Banner Ranch. (Both, McCleary family.)

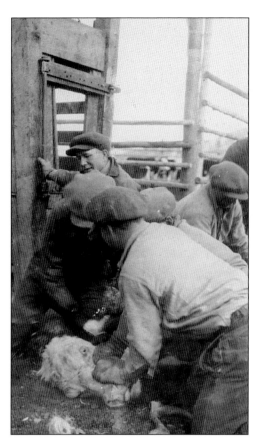

Horned livestock have always been a source of concern for ranchers because of the safety risks they pose to ranch hands and the livestock themselves. These images show a dehorning on the Banner Ranch in the 1930s; ranchers removed the horns from their cattle, making them easier to work with and safer when sorting cattle in a confined space. (Both, McCleary family.)

Saddles and other tack were some of the most important pieces of equipment a cowboy could own when working on a ranch. Numerous saddle-makers set up businesses in central Wyoming to provide this equipment, including A.J. Williamson; some of his handiwork is displayed in this 1925 image. (McCleary family.)

Here, Dogie Steed, a cowboy for several ranches around Casper, drags a calf that is about to be branded. Using hot irons to mark the hide of a calf to show ownership is an old tradition. Although this scene is from the V Bar V Ranch after it was sold to Dr. H.E. "Harry" Stuckenhoff in 1946, ranch life has not changed much from 1876 to the present day. (Bobbi Stuckenhoff.)

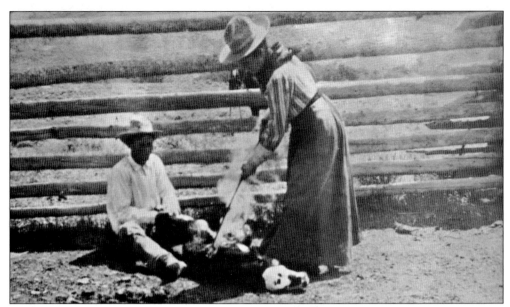

In the early days of Natrona County, women performed a wide variety of tasks on their homesteads. They watched over the house, children, and gardens and also helped with the rather nontraditional tasks of ranch work, including the branding of calves, as shown in this early 1900s image. (Casper Centennial Corporation Collection, CC WI IC.)

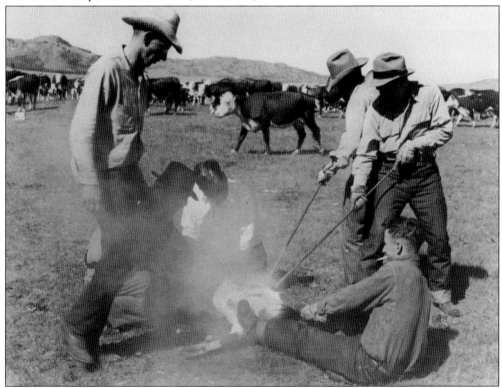

Bryant "Cactus" McCleary (standing at left) helps calm a calf while it is branded with the V Bar V brand at the ranch. (Bobbi Stuckenhoff.)

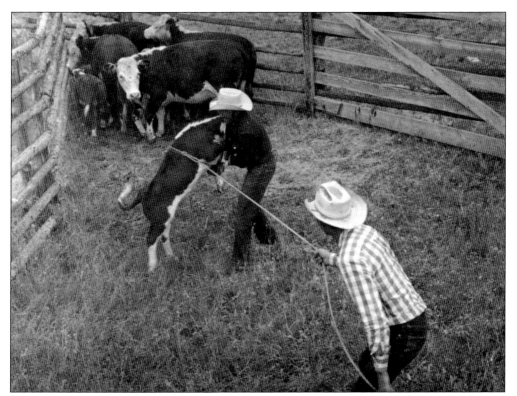

Sometimes roping a calf is harder than it looks, as shown in this photograph from the Banner Ranch. Such instances often lead to colorful language emerging from the cowboys hurrying to solve the crisis, but they also result in laughter when all is said and done. (McCleary family.)

At a branding on his family's V Bar V Ranch, young Eddie Stuckenhoff (right) holds the hind legs of a calf while waiting for the branding crew to arrive. (Bobbi Stuckenhoff.)

Some ranching traditions are still celebrated at the end of a tough job, as illustrated in this photograph taken on the V Bar V Ranch in 1947. (Bobbi Stuckenhoff.)

BIBLIOGRAPHY

Bille, Ed. *Early Days at Salt Creek and Teapot Dome*. Casper, WY: Mountain States Lithographing, 1978.

Brooks, Bryant B. *Memoirs of Bryant B. Brooks*. Glendale, CA: The Arthur H. Clark Company, 1939.

Casper Zonta Club. *Casper Chronicles*. Casper, WY: Mountain States Lithographing, 2010.

Cronin, Vaughn. *Casper*. Casper, WY: Vaughn's Publishing and Multimedia, LLC, 2009.

Dobson, G.B. "Wyoming Tales and Trails." www.wyomingtalesandtrails.com, 2006.

Garbutt, Irving, and Chuck Morrison. *Casper Centennial: Natrona County, 1889–1989*. Dallas, TX: Curtis Media Corporation, 1990.

Hunt, Rebecca. *Natrona County: People, Place and Time*. Virginia Beach, VA: The Donning Company Publishers, 2011.

Junge, Mark. *A View from Center Street*. Denver, CO: Sprint Denver, Inc., 2003.

King, Robert. *Trails to Rails: A History of Wyoming's Railroads*. Casper, WY: Mountain States Lithographing, 2005.

Kukura, Edna G., and Susan Niethammer True. *Casper: A Pictorial History*. Virginia Beach, VA: The Donning Company Publishers, 1986.

Larson, T.A. *Wyoming: A History*. New York City: W.W. Norton & Company, 1977.

Mokler, Alfred J. *History of Natrona County, Wyoming, Centennial Edition*. Casper, WY: Mountain States Lithographing, 1989.

Perry, Robert. *Sheep King: The Story of Robert Taylor*. Grand Island, NE: The Prairie Pioneer Press, 1986.

Randall, Art. *Casper "Old Town" and Fremont, Elkhorn and Missouri Valley Railroad*. Casper, WY: self-published, 1991.

Rea, Tom. *The Hole in the Wall Ranch: A History*. La Vergne, TN: Pronghorn Press, 2010.

Shallenberger, Percy H. *Letters from Lost Cabin*. Doug Cooper, ed. Casper, WY: Mountain States Lithographing, 2006.

ABOUT THE AUTHORS

Con Trumbull was born and raised on his family's ranch southeast of Casper. A fifth-generation Wyoming rancher, he has always had a love of the history of Wyoming. Trumbull graduated from Natrona County High School, attended Casper College, and finally earned a Bachelor of Science degree in geology at Colorado Mesa University in Grand Junction, Colorado. He is a member of the Fort Caspar Museum Association and volunteers at the museum.

Kem Nicolaysen was born in Casper and, from an early age, was always interested in the stories and histories of his pioneer relatives. He credits his grandmother Mary Hester with instilling in him a deep interest in family history and a love for Wyoming. After teaching English for several years, he returned to Casper, where he works on his family ranch. He holds a master's degree in Literature Studies from Western Washington University and is a member of the Natrona County Historical Society and the Natrona County Pioneer Association.

ABOUT THE ORGANIZATIONS

The Fort Caspar Museum Association, a nonprofit organization, was founded in 1987 to support preservation and education activities at Fort Caspar Museum through financial support and volunteer time.

The Natrona County Historical Society was founded to commemorate and honor the history of Casper and Natrona County. Throughout the past century, it has played a leading role in the education about and promotion of Natrona County history.

Discover Thousands of Local History Books
Featuring Millions of Vintage Images

Arcadia Publishing, the leading local history publisher in the United States, is committed to making history accessible and meaningful through publishing books that celebrate and preserve the heritage of America's people and places.

Find more books like this at
www.arcadiapublishing.com

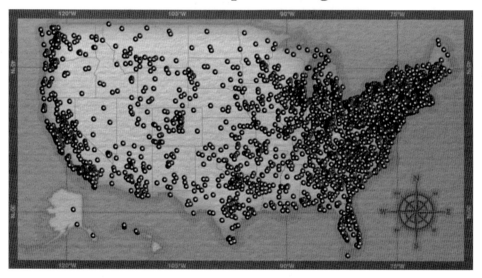

Search for your hometown history, your old stomping grounds, and even your favorite sports team.